Colour

A Social History

OLIVER GARNETT

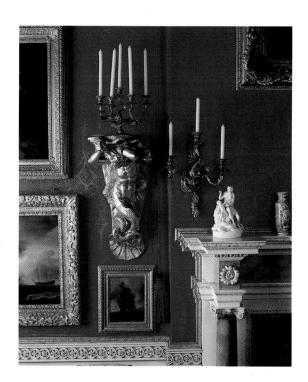

The National Trust

Loving Colour

Brightly coloured hard stones decorate the 'Pope's Cabinet' at Stourhead in Wiltshire.

When the cartoonist Osbert Lancaster was asked what his favourite colour was, he responded: 'That's an idiotic question to ask anyone who's an artist. Colours only have any reality in conjunction with other colours.'

True enough. Nevertheless, this book tries to explain why specific colours were favoured by particular people in particular places and at particular periods. It also looks more generally at how colour has been explained, manufactured, applied to walls, symbolically represented, exploited as status symbol, projected through space, and decayed with time. Because this is a National Trust book, I have drawn my examples largely from National Trust properties, but I also quote liberally from people both real and imagined who can often provide a revealing insight into the ways colour has been understood in the past. The complex, usually fragmentary and faded, evidence of historic paint colours has been exhaustively researched and explained by Ian Bristow. I have taken the approach of the social historian, and so said very little about colour theory, which has been brilliantly surveyed by John Gage in *Colour and Culture*. I have also not ventured into the huge subject of colour and race, which deserves much more extended treatment than I could give it here.

Writing in *The Stones of Venice* (1851–3) about the city most closely associated with colour in the European imagination, the art critic John Ruskin claimed that 'the purest and most thoughtful minds are those which love colour the most'. Wishful thinking perhaps, but this little book is meant for all those who love colour in its many forms and in whatever fashion.

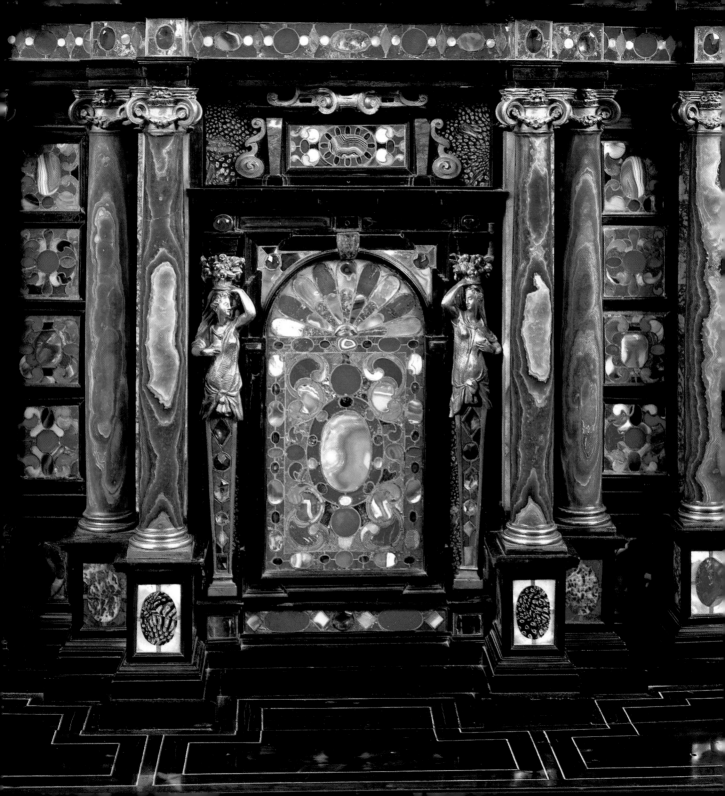

The Rainbow's End

A rainbow over Bateman's in Sussex.

In August 1665 the Great Plague reached Cambridge from London. The University was closed, and the twenty-two-year-old Isaac Newton was forced to leave his studies at Trinity and return to his birthplace in the Lincolnshire hamlet of Woolsthorpe. Here, early the following year, he performed the *experimentum crucis* – the 'crucial experiment'. In a darkened room, he projected a beam of sunlight through a prism on to a white wall about twenty-two feet away. According to earlier colour theorists, he should have produced a curved rainbow; in fact, he observed a long oblong spectrum of seven distinct colours: red, orange, yellow, green, blue, indigo and violet. From this, he concluded that 'light consists of rays differently refrangible [refractable, as we would say]': 'to the same degree of refrangibility ever belongs the same colour, and to the same colour ever belongs the same degree of refrangibility'. 'Some rays are disposed to exhibit a red color, and no other, some a yellow and no other ... and so of the rest.' Newton returned to Cambridge the following March, and in 1672 published his 'New Theory about Light and Colours', upon which our whole understanding of the science of colour is based.

For centuries, jewellers and their customers had appreciated the beautiful effects of refracted light, even if they didn't understand the science. The 'fire' of cut and polished diamonds depends on their power to refract light and has always been immensely prized. A portrait at Hardwick Hall in Derbyshire shows Elizabeth I wearing a magnificent jewel of huge, chunkily cut diamonds pinned to her skirt. By the eighteenth century, the phenomenon could be enjoyed more widely. The Assembly Rooms in Bath are lit by chandeliers which contain hundreds of faceted crystal drops. On a sunny day, they cast a myriad little Newtonian rainbows across the rooms.

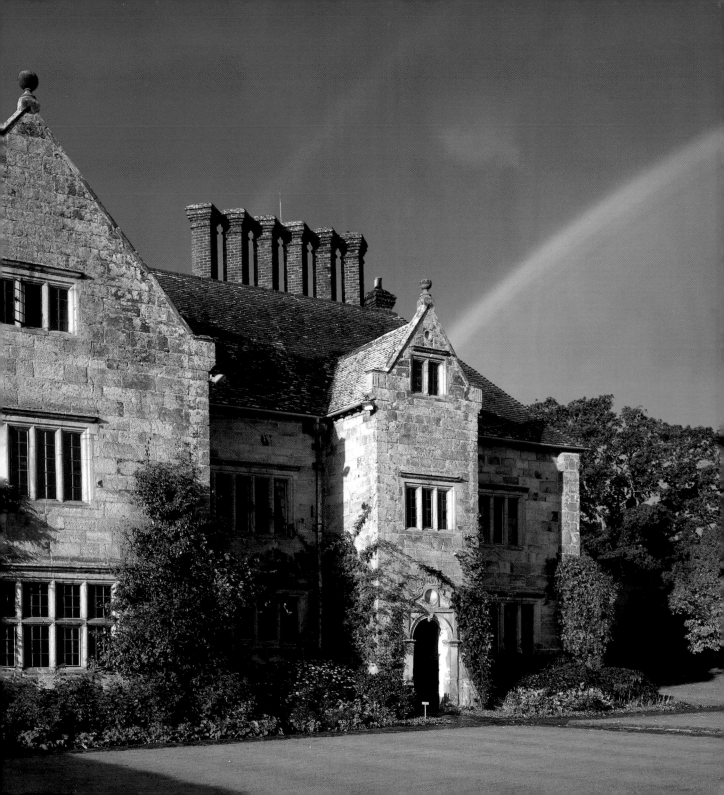

Pigments and Dyes

'The rainbow comes and goes', as Wordsworth famously recollected. To achieve more permanent colours, you need pigments, which have traditionally been extracted from plants and minerals. The National Trust has replanted the back garden at Lavenham Guildhall in Suffolk with some of the plants used to make dyes in the Middle Ages. It was on the cloth these dyes coloured that Lavenham and the other wool towns of medieval East Anglia depended for their prosperity.

The Elizabethan court revelled in bright colours, which were expensive to produce, and so a visible sign of status. Sumptuary laws also tried to restrict the wearing of particular colours to the upper classes. It was only in the eighteenth and nineteenth centuries that new artificial pigments such as Cobalt Blue and Chrome Yellow became widely available with advances in chemistry. Colourmen also became more skilled at extracting pigments from natural sources. Madder lake, a rose-to-purple pigment derived from the root of the madder plant *rubia tinctorum*, was a vital dye for the textile industry, but in the eighteenth century most of it had to be imported from Holland at considerable expense. In 1807 the pioneering colourman George Field invented a new press for extracting the dye from the root more efficiently and then distilling it.

During the nineteenth century, paint manufacture was industrialised by firms like Mander Bros. of Wolverhampton, whose success paid for the building of Wightwick Manor not far from the town. Today we take it for granted that house paint will be uniformly priced, easy to apply, and permanent. In the past, this was not so. Indeed, practical constraints may have determined the colours we find in a historic house just as much as matters of taste. So, for instance, plain stone colours were widely used in early eighteenth-century entrance halls not only because they helped to emphasise the architectural quality of the space, but also because they were cheap, hard-wearing and did not fade. For the same reason, they were equally popular for the servants' quarters. By contrast, bright reds and yellows were expensive and fugitive, and so tended to be restricted to the most lavishly decorated private rooms, from which sunlight could easily be excluded. Most expensive of all was natural ultramarine blue, which was restricted to pictures because of its cost. A cheaper alternative was smalt blue, but this was difficult to apply. Some colours were available only as oil paint (used mostly on woodwork) or water-based distemper (mostly for plasterwork), which restricted the choice still further.

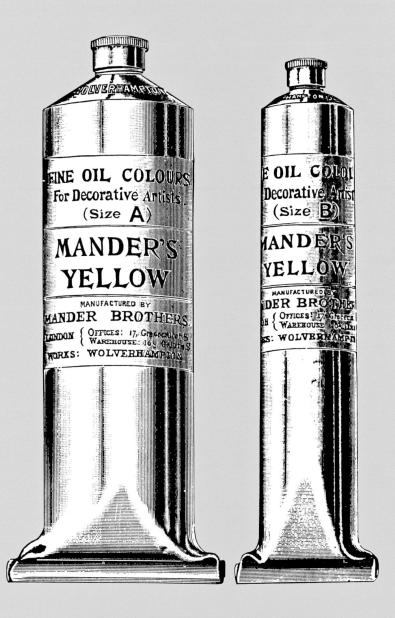

The House-painter's Trade

The Best Staircase at Dyrham Park in Gloucestershire shows the skill of the late seventeenth-century house-painter. It still preserves the original marbling on the walls and cedar graining on the underside of the stairs.

When the architect Sir Roger Pratt was designing Kingston Hall (now Kingston Lacy) in Dorset in the 1660s, he carefully measured up the house so that the cost of painting it could be accurately calculated. He even gave common-sense advice on what colours to paint the walls: 'The colours for rooms ought not to be taken at random, but to be chosen according to the much or little light, or space of the places etc.' In the seventeenth century, the best house-painters were skilled craftsmen, who had to be able to mix their own paints and to imitate marble or the grain of walnut, cedar, oak and many other more exotic woods. But in the eighteenth century cheaper, ready-mixed paint became widely available, and this kind of elaborate painted decoration went out of fashion. As a result, house-painting declined until it was the least skilled of all the building trades. By 1756 house-painters were being paid as little as 6d per square yard for three coats of oil paint. In *The London Tradesman* (1747) Robert Campbell commented on the uncertainty of their lives:

> There are a vast number of hands that follow this branch, as it may be learnt in a month, as well as in seven years: plaisterers, whitewashers, and every-body that can handle a brush now set up for house-painters.... There is not bread for one third of them; and at all times in the City of London and suburbs they are idle at least four or five months in the year. Their work begins in April or May, and continues till the return of the company to town in winter, when many of them are out of business.... The journeymen of this branch are the dirtiest, laziest, and most debauched set of fellows in and about London.

Conditions were little better by the early twentieth century, when an Irish house-painter named Robert Noonan began working in Hastings. Noonan's experiences formed the basis for his novel, *The Ragged Trousered Philanthropists* (1914), which is a biting, Socialist critique of the building trade of that time. 'Misery' Hunter, the foreman of the building firm of Rushton & Co. ('First-class Work only at Moderate Charges'), takes every opportunity to skimp. He is furious to discover that two coats of paint are being put on when he had estimated for three; one is sure to be enough: 'Just dust it down and slobber the colour on.'

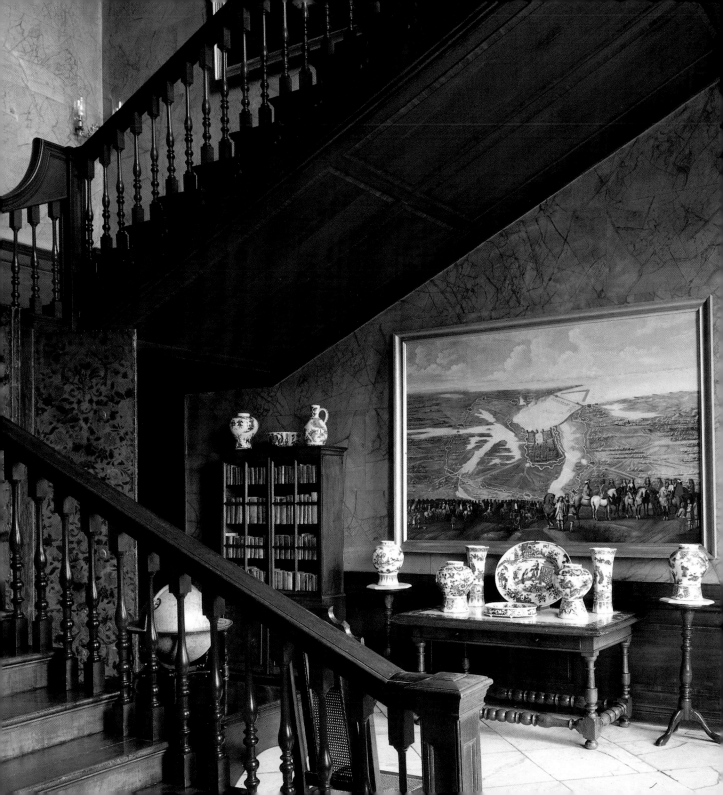

The Language of Colour

'Colours speak all languages.' So said the critic Joseph Addison in 1712. But colour also has many kinds of symbolic language of its own. One of the most sophisticated and enduring is heraldry. It seems to have developed more or less simultaneously across Europe in the mid-twelfth century. In that era, knights wore closed helmets which concealed their faces, so some form of colourful distinguishing insignia was essential, if not in the mêlée of a medieval battle, then at least to proclaim their rank and identity in its formalised counterpart – the tournament. The language of heraldry, known as blazon, was gradually codified by professional bodies of heralds (in England, the College of Arms), who guarded the rights of families, and later institutions, to bear arms. The range of colours (or tinctures) that can be used on a coat of arms is very restricted, although the shades can vary considerably. There are two metals: gold (*Or*), represented by yellow; and silver (*Argent*), represented by white. The five principal plain colours are: blue (*Azure*), red (*Gules*), black (*Sable*), green (*Vert*) and purple (*Purpure*). Finally, there are two furs: *Ermine* (black tails on white) and *Vair* (a blue and white pattern). Cinderella's glass slipper was in fact merely fur: a mishearing of *Verre* for *Vair*.

Heraldic colours were often chosen for the livery of country-house servants. At Powis Castle in Powys around 1900 the footmen wore navy blue suits piped with scarlet during the day, and navy and scarlet tailcoats in the evening, as the principal colours of the Herberts' coat of arms are blue and red. More relaxed forms of heraldry still determine the colours of jockeys' silks and footballers' team shirts, which occasionally have a particular local significance. So, for instance, York City's chocolate and cream strip recalls the Rowntree's and Terry's chocolate factories in the city. Where once soldiers wore the coat of arms of their master into battle, today footballers bear the logos of their corporate sponsor.

Early writers on heraldry tried to establish a hierarchy of colour – with white at the top and green at the bottom – and to attribute particular qualities to individual heraldic colours. By the eighteenth century, such notions had been debunked, but it is certainly true that, in the sophisticated world of the Elizabethan court at least, colour was interpreted in just this way. Black symbolised grief and constancy; white faith and humility; yellow joy; green love; red courage; turquoise jealousy. It was by deliberate choice that Mary Queen of Scots went to her execution dressed in black satin, white lace and crimson velvet.

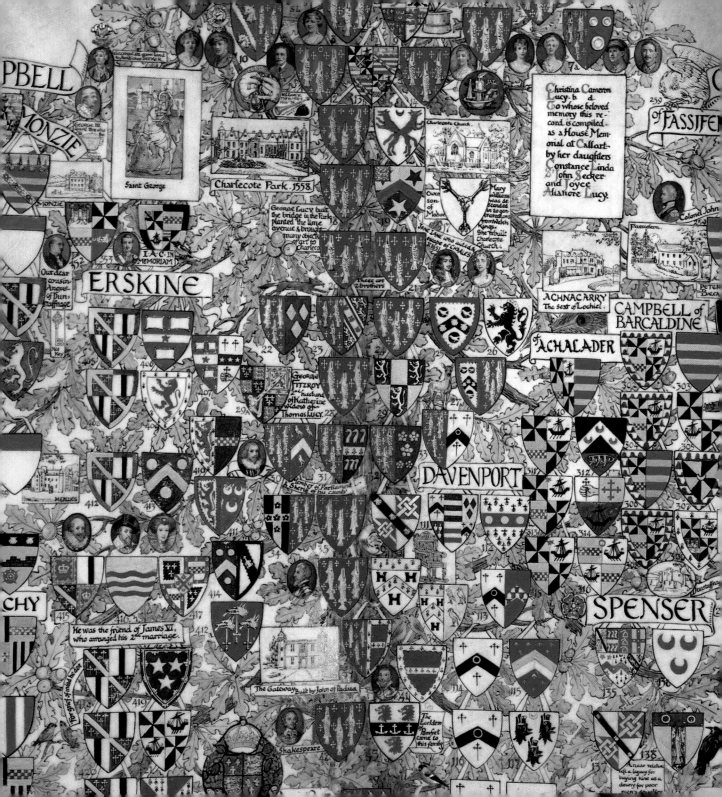

PBELL

MONZIE

MONZIE

Saint George

GEORGE III gave land to Archibald Secker

Charlecote Park. 1558.

George Lucy built the bridge in the Park, planted the lime avenue & brought many objects of art to Charlecote

ERSKINE

Our dear cousin Angus of Dun Staffage.

J.A.C. IN MEMORIAM

MENZIES

He was the friend of James VI, who arranged his 2nd marriage.

CHY

To quest of mis...can

The Gateway built by John of Padua

Shakespeare

Charlecote Church.

Own son of Mabo?

Jane Lane who aided the escape of CHARLES 1651

These are 2 brothers

GEORGE FITZROY 2nd husband of Katherine widow of Thomas LUCY.

Member of Parliament & Sheriff of this county

Mary Williams was descended to to son...in...law from Welsh Kings. She rebuilt Charlecote Church.

Christina Cameron Lucy. b. d. To whose beloved memory this record is compiled as a House Memorial at Callart by her daughters Constance Linda & John Secker and Joyce Alianore Lucy.

of FASSIFE

Colonel John

Fassifern.

PETER BALCA

ACHNACARRY The Seat of Lochiel.

CAMPBELL of BARCALDINE

ACHALADER

DAVENPORT

SPENSER

The Earldom of Pomfret came to this family

Dunstaffnage

A near relative left a legacy for buying kine as a dowry for poor men's daughters

Colour and Ownership

Colour is one of the simplest ways to indicate ownership. Farmers usually mark their own sheep with splashes of colour when they let them out to graze on the high fells of the Lake District and the Pennines. Traditionally, this dye was supplied by a reddleman, like Diggory Venn in Thomas Hardy's *The Return of the Native* (1878): 'Like his van, he was completely red. One dye of that tincture covered his clothes, the cap upon his head, his boots, his face and his hands. He was not temporarily overlaid with the colour: it permeated him.'

More eccentric owners had been known to dye other animals. A friend of Lord Berners claimed that in the 1930s at Faringdon, his Oxfordshire home, 'it was a common sight to see one's host wearing a huge green apron standing in the drive in front of great basins of magenta, copper green and ultramarine dye, and with the help of men-servants ceremoniously dipping, one after another, his white pigeons and once, I believe, some swans, a duck and a white poodle.'

Buildings as well as animals can be coloured. Perhaps the prettiest method is to apply a coat of coloured limewash to the outside walls. The architectural writer Alec Clifton-Taylor relished the result, 'much of it so succulent that one finds oneself turning out half the contents of the larder to describe it. There are tomato red, raspberry-and-cream pink, strawberry-ice pink, peach pink, salmon pink. We meet orange and apricot, lemon yellow, lime yellow, butter yellow, biscuit and cream. Apple and olive round off this gastronomic galaxy.' On many old family estates, all the cottages are colour-washed the same shade: for instance, buildings are a reddy orange on the Aclands' Killerton estate in Devon, and a pale yellow at Holnicote in Somerset. Sometimes, it is the doors and window frames that are painted a uniform colour, though these so-called 'estate colours' often turn out to have been chosen as much for reasons of economy as from pride in possession.

In the back corridors of many a country house hang large estate maps which mark the extent of the demesne in colour, just as the territories of the British Empire were traditionally picked out in pink. The same approach was applied in slightly unexpected places. Harold Nicolson recalled the gargantuan Edwardian breakfasts of his youth, when the pots of Indian and China tea 'were differentiated from each other by little ribbons of yellow (indicating China) and of red (indicating … our Indian Empire)'.

Colour is still used to record possession – but against the threat of burglary: marker pens leave an invisible trace, which can only be seen under ultraviolet light.

Gold

The gilded ceiling
of the Golden Room
at Kingston Lacy
in Dorset.

The Roman poet Ovid divided time into four ages of declining splendour: Gold, Silver, Bronze and Iron. The same hierarchy applied to the materials themselves, and to the way they were used in decoration. Most owners, however, did not go as far as Titus, 77th Earl of Groan, whose crumbling castle of Gormenghast included silver, bronze and iron rooms, according to Mervyn Peake's novel, *Titus Groan* (1946).

The Golden Age was a time of Eden-like bliss, and gold was traditionally the most precious of metals, not only because it was rare, but also because it was untarnishable. At the same time, gold has symbolised excess since at least the era of the Roman Emperor Nero's Domus Aurea, the palace that he decorated throughout with gold. Not surprisingly, the irredeemably extravagant Prince Regent favoured gold everywhere in his decorative schemes.

In the country house, gold is found most often as gilding on picture frames, because, as the French painter Nicolas Poussin explained, 'It unites very sweetly with the colours without clashing with them.' Immensely subtle effects could be created by using different kinds of gold leaf, by the different techniques of oil and water gilding, and by burnishing the surface to different degrees.

At Kingston Lacy between 1838 and 1855, William John Bankes created an entire gilded room as a 'frame' for the superb collection of dark-toned Spanish paintings that he had acquired forty years before. The gilt picture frames hang against panels of gilded and painted Spanish leather beneath oval gilded cartouches, in which the paintings are described – in gold lettering, naturally. But the climax is the gilded and coffered ceiling, which is said to have come from the Palazzo Contarini degli Scrigni on the Grand Canal in Venice. At night, when the wall-lights reflect in their gilded sconces, the room glows.

Gold framed not only pictures, but also furniture and ceramics, in the form of ormolu mounts. The very rich even used gold out of doors, particularly on garden sculpture. When the Duke of Devonshire gilded his window frames at Chatsworth, his Derbyshire rival, Nathaniel Curzon, was determined not to be outshone – literally – and did the same with his new house at Kedleston. In the 1920s Sir Philip Sassoon went one stage further at 25 Park Lane in London and gilded his drainpipes.

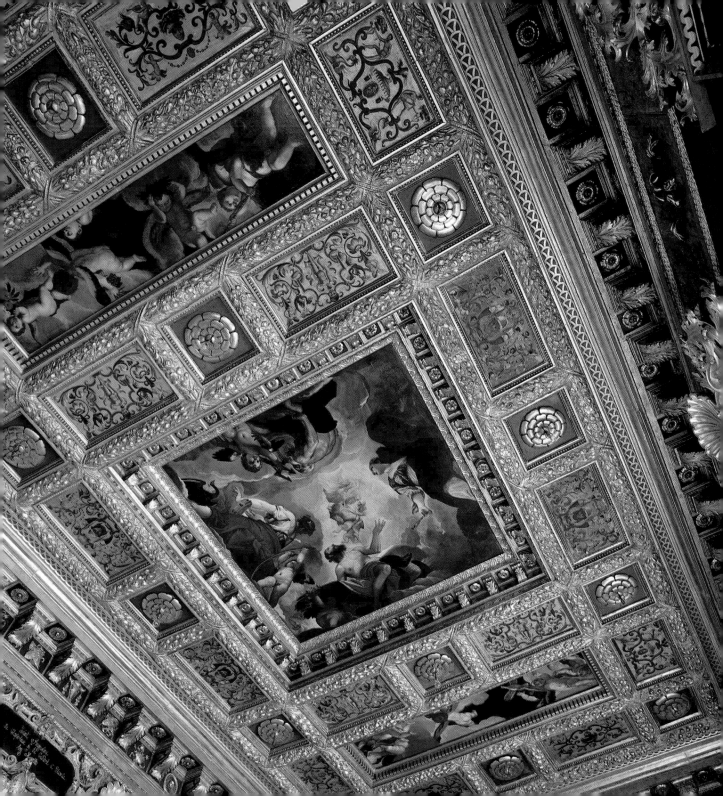

Silver

Silver appears on the dining table at all periods, and, in the seventeenth century, was heaped up on the buffet, purely for display. The word gave its name to a whole class of literature – the 'silver fork' novel, in which Disraeli and others described the smart London salons of the 1820s and 1830s. The critic William Hazlitt bitterly attacked the apparent triviality of these books: 'Provided a few select persons eat fish with silver forks, he [the novelist Theodore Hook] considers it a circumstance of no consequence if a whole country starves.'

Silvering was used for room decoration much more rarely than gold (or indeed most other colours), because it tarnishes so easily, as George Lucy realised, when he was redecorating Charlecote Park in Warwickshire in the early 1760s. His steward, Standbridge, had recommended picking out the doors and cornices in silver, but Lucy refused, because he believed only a constant fire in the room would keep the decoration from turning black. This did not stop the Prince Regent decorating the Saloon of the Brighton Pavilion with a largely silver scheme in 1804. Two years later, he is said to have given Lady Irwin some rolls of Chinese wallpaper, which she later framed with a silvered cornice and fillets in the Chinese Drawing Room at Temple Newsam in Yorkshire. The taste for silver decoration may have been inspired by Marie-Antoinette, and it was certainly associated particularly with feminine interiors.

Perhaps the most extravagant use of silver decoration in a country house is at Manderston in Berwickshire, which was remodelled by John Kinross for the immensely wealthy Sir James Miller, 2nd Bt., in 1894–1905. When Kinross enquired how much he had to spend, Sir James replied: 'It doesn't really matter.' This encouraged the architect to design a silver-plated staircase balustrade modelled on that in Marie-Antoinette's Petit Trianon at Versailles. To disassemble, polish and replace the staircase metalwork takes three people three weeks. Not surprisingly perhaps, the staircase was left black between 1910 and 1980, when it was restored. Manderston also has a silver-plated bath.

Silvered picture frames are rare outside Ecuador, although a huge one survives on a seventeenth-century architectural view by Samuel van Hoogstraeten at Dyrham Park in Gloucestershire. To prevent tarnishing, silvered frames were sometimes varnished, but this was slightly self-defeating, because the varnish itself would turn brown with time; indeed, varnished silver leaf was sometimes used as a cheap way of imitating gilding.

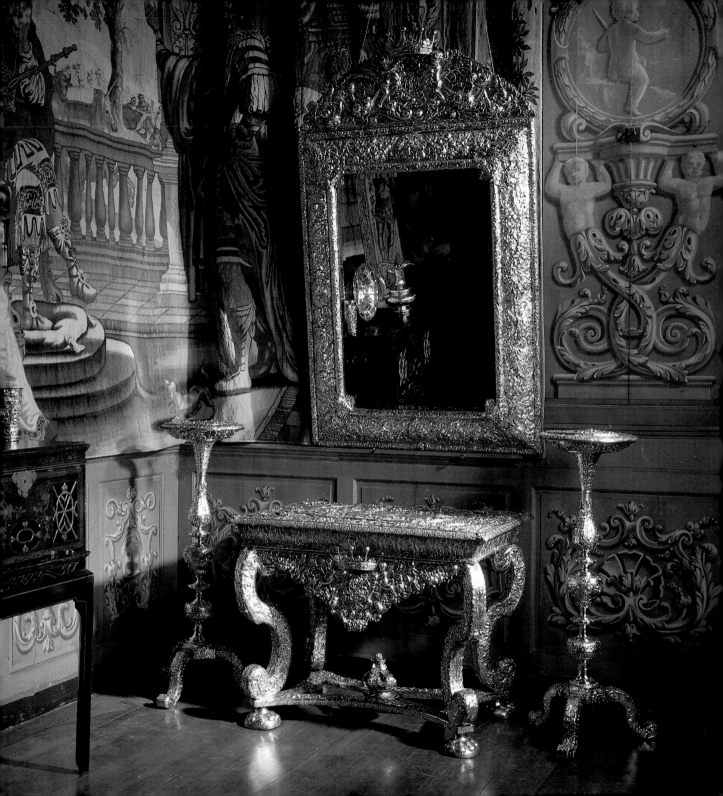

Bronze

This bronze bust of Lord Herbert of Chirbury in the Library at Powis Castle in Powys was conceived by the French sculptor Hubert Le Sueur, who introduced the art of bronze portrait sculpture to Britain in the 1620s.

According to the late eighteenth-century Neo-classical ideal, with its emphasis on 'pure' form, sculpture should be either white or brown. If white, it should be made of marble and massive: hence, the profusion of white chimneypieces in country houses, supported by carved figures known as 'atlantes'. If brown, it should be made of bronze and sit on a table or bookcase. Indeed, the word 'bronze' became synonymous with a particular kind of small sculpture. More elaborate colour on sculpture was a distraction, and the vulgar illusionism of wax portrait sculpture, with its overtones of Madame Tussaud, should be avoided at all costs.

Bronze the metal and bronze the colour are not always quite the same thing. When cast in bronze, garden sculpture will rapidly turn green, if left unprotected outside. Indeed, the oxide formed had been a popular green pigment for artists since classical times: hence its common name verdigris (literally 'green of Greece'). In the late eighteenth century, there was even a brief fashion for painting doors and mouldings to simulate the green patina of bronze verdigris. If you didn't want your bronze garden sculpture to turn green, you could paint it white, which had the added advantage of making it resemble marble – the preferred, but more expensive, material for monumental sculpture. The same problems did not apply with indoor sculpture, but that did not stop many dealers and collectors covering their bronze statuettes with a heavy brown varnish in an attempt to simulate the patina of Renaissance bronzes. Many apparently bronze objects in country houses are not in fact made of bronze at all. Indeed, most of the busts of writers and philosophers that look down from the top of library bookcases turn out to be plaster casts painted a bronze colour rather than of bronze itself.

Following the discovery that both classical and medieval sculptors had applied colour to their work, there was a revival of interest in polychrome sculpture in the early nineteenth century, climaxing in John Gibson's *Tinted Venus*, a marble statue with blue eyes and red lips which caused a sensation in 1854. But most sculptors remained more concerned with form than colour, and the invention of black and white photography only reinforced this attitude towards sculpture. As Rodin exclaimed in 1912: 'Colour! Try to give your work colour! This is an expression a sculptor should never use!' When he came to sculpt George Bernard Shaw in 1906, he concentrated on trying to distil both his distinctive character and body into a modest head and shoulders bust; the material used, and least of all its colour, were comparatively unimportant.

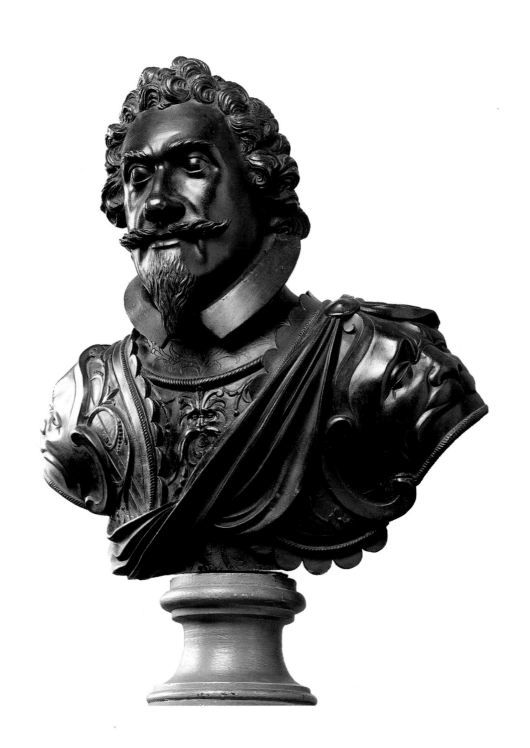

Iron and Steel

In 1638 eight wooden casement windows at Dyrham were painted to simulate steel. Fifty years later, outside doors at Dyrham were still being painted an iron colour. But the colour of iron itself is rarely found outside because, of course, the metal will rust if left unprotected from the elements. In the Middle Ages, wrought-iron gates were sometimes varnished, treated with black pitch, tinned or painted. In the seventeenth century, the fashion developed for painting ironwork in bright colours: blue, green, white and bronze, for example. In 1673–4 the gates at Ham House were described as 'smalt blew'. In the late eighteenth century, Robert Adam's iron staircase balustrade at Osterley Park near London was a 'fine garter-blue', and the Spencers continued painting the railings of Althorp and their London house a bright blue as a sign of their allegiance to the Whig leader Charles James Fox, whose party colours were buff and blue. But during the eighteenth century, more and more people preferred to paint their iron balconies and railings a cheap, practical – and boring – black. A French visitor to England, Jacques Henri Meister, writing in 1791, complained at 'the sight of a number of heavy black iron bars.... Perhaps gilding might make them more lively, or painting them a gayer colour.' But black outside ironwork has remained, apart from a brief craze for blue metal window frames in the Thatcherite building boom of the mid-1980s; once again, the choice of colour may have had political connotations. When the clock-face of Big Ben had to be repainted at the same period, returning to Pugin's brashly colourful original scheme was considered. But this was predominantly blue, and the minister in charge feared it would be seen as Tory triumphalism. Safe black was again preferred.

Iron may rust, but steel does not, and the bare metal has become ubiquitous in modern interiors – almost the hallmark of contemporary good taste. It has in fact been popular for more than a century. In 1858 William, 8th Marquess of Lothian commissioned the young interior designer John Hungerford Pollen to redecorate several of the larger rooms at his Norfolk house, Blickling Hall. For the Long Gallery Pollen designed a colourful frieze painted with animals and a gigantic neo-Assyrian stone chimneypiece. Joshua Hart & Sons made the equally exuberant steel firedogs, which are topped by the Lothian coronet and 'sun-in-splendour' motif. In the Dining Room at Standen in Sussex, the architect Philip Webb went one stage further, using steel not only for the fire-furniture, but also for the fender and the smoke-hood, which has a built-in rack on which to warm the dinner plates.

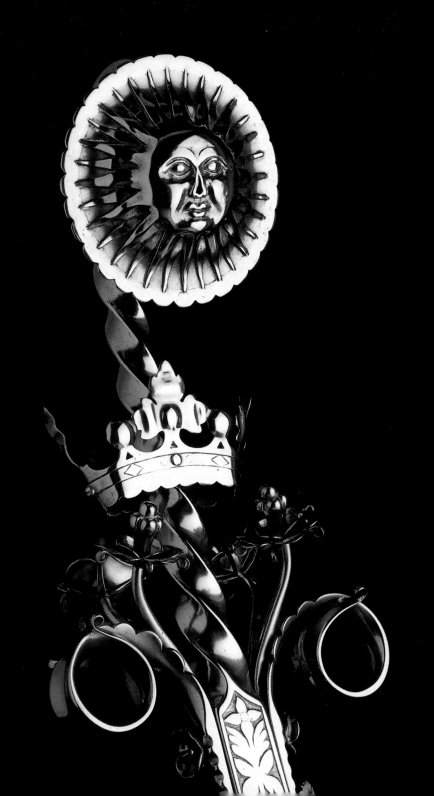

White

In her gardening column in The Observer, Vita Sackville-West described the effect she was looking for in her white garden:

'I visualize the white trumpets of dozens of Regale lilies, grown three years ago from seed, coming up through the grey of southernwood and artemisia and cotton-lavender, with grey-and-white edging plants such as Dianthus 'Mrs Sinkins' and the silvery mats of Stachys lanata, more familiar and so much nicer under its English names of Rabbits' Ears or Saviour's Flannel. There will be white pansies, and white peonies, and white irises with their grey leaves ... at least I hope there will be all these things.'

In *Merry Hall* (1951), the writer Beverley Nichols looked back nostalgically from the dinginess of post-war Britain to the brighter world of 1930s High Society: 'The tinkling laughter of champagne, the music which goes faster and faster, the sheer profusion of white – white dresses, white roses, white tablecloths – the dizzy gay life of the old houses.'

White has always been a symbol of wealth, because white clothes show the dirt quickest and so need cleaning most often. Before modern detergents and bleaches, the easiest way to whiten fabric was to lay it out in the sun. Most large country houses had a bleaching ground, and an eighteenth-century view of Uppark in Sussex shows one in operation, with sheets being stretched out to dry and whiten.

From at least the seventeenth century the most popular form of white paint was lead white, which John Smith's *The Art of Painting* (1676) noted was 'much used ... for the last colour of windows, doors, poles, posts, rails, palissados, or other timber work'. It was also used in cosmetics – with disastrous results, as lead is highly poisonous. In 1752 the 6th Earl of Coventry tried to get his beautiful young wife Maria Gunning to give up wearing lead white make-up because of the dangers. When she refused, he chased her round the dinner table, and wiped it off with his napkin. But she still wouldn't listen, and eight years later, at the age of only twenty-eight, she was dead.

White was never more fashionable than in the early 1930s. This was the era of Jean Harlow (star of *Platinum Blonde*, 1931) and Marlene Dietrich (*The Blonde Venus*, 1933). In 1932 the theatre designer Oliver Messel caused a sensation with the all-white bedroom set for the Cochran-Reinhardt revue, *Helen!* The following year the interior designer Syrie Maugham published colour photographs of her all-white sitting room in Chelsea. She avoided dead white and cream (too suburban), but used practically every other shade – ivory, oyster, parchment, pearl – for the sofas, walls, curtains and carpet (by Marion Dorn, who created the pattern with texture rather than colour; another of her carpets is on show at Coleton Fishacre in Devon). The one black element, the grand piano, was hidden behind a white lacquer screen. The room was not desperately practical, and the mirror screen tended to shed strips on to unwary guests when it got hot, but it was influential nevertheless.

It was partly perhaps to this white world of the 1930s that Vita Sackville-West was also looking back when she created her famous white garden at Sissinghurst in Kent in the early 1950s.

Black

'Duties of the Housemaid' from Mrs Beeton's Book of Household Management (1861):

'The cinders disposed of, she proceeds to black-lead the grate, producing the black lead, the soft brush for laying it on, her blacking and polishing brushes, from the box which contains her tools. This housemaid's box should be kept well stocked. Having blackened, brushed, and polished every part, and made all clean and bright, she now proceeds to lay the fire. Sometimes it is very difficult to get a proper polish to black grates, particularly if they have been neglected, and allowed to rust at all.'

Since the late Middle Ages, black has been the colour of mourning (before that, it was plain grey or brown). Mourners wore black, used black-edged writing paper, and decked whole rooms in black. When Sir Ralph Verney died in 1696, his son John ordered that the Hall at Claydon in Buckinghamshire should be hung with black baize, 'the entry from the Hall door to the Spicery door, and the best Court Porch, likewise the Brick parlour from top to bottom', where the three great tables and a dozen chairs were also to be covered with black. Even expensive gilded furniture, like the stools in the King's Room at Knole, was sometimes painted mourning black. By the nineteenth century, the mourning etiquette of colour had become minutely graduated for women. In the first stage of mourning, you wore dull, matt, deep black wool; at the next stage, lighter fabrics – silk or a silk-wool mixture – were permissible, but still full black; then black was combined with white or grey; finally, you could wear lavender or mauve.

Black meant old. In the mid-eighteenth century there was a craze for black ebony furniture among antiquarian collectors like Horace Walpole, who believed – incorrectly – that it was Tudor. Walpole's friend Richard Edgcumbe bought examples for Cotehele in Cornwall, which can still be seen in the Old Drawing Room there.

There was money to be made from black. In the early nineteenth century the draper James Morrison became a millionaire selling black funeral crêpe and spent it on acquiring Basildon Park in Berkshire and filling it with superb paintings. Frederick Cawley's patented recipe for black dye proved so profitable when Queen Victoria died in 1901 that it paid for Berrington Hall in Herefordshire.

For obvious reasons, black was never a popular colour for room decoration outside periods of mourning, although in 1939 Duncan Grant experimented with a black stencilled wallpaper for the dining room at Charleston in Sussex. In 1932 Paul Nash specified all-black fittings for the famous bathroom he designed for Tilly Losch, the dancer wife of the Surrealist collector Edward James. Ralph Dutton built himself a completely black bathroom for Hinton Ampner in Hampshire in the 1960s.

Black symbolises decadence, but also power and the status quo; it never goes out of fashion. At a more mundane level, it hides the dirt, so was the preferred colour for kitchen ranges until the modern obsession with hygiene. But even keeping a range gleaming black was a laborious daily chore for the housemaid. Yet it was a task Charlotte Brontë positively enjoyed, as she explained to a friend in 1839: 'Human feelings are queer things. I am much happier black-leading the stoves ... at home than I should be living like a fine lady anywhere else.'

Brown

The great late seventeenth-century wood-carver Grinling Gibbons challenged contemporary taste for dark wood, preferring to leave his limewood carvings their natural pale creamy colour. Those in the Carved Room at Petworth in Sussex (illustrated opposite) were meant to appear lighter in tone than the oak panelling to which they were fixed. By the late eighteenth century, dust and dirt had turned them a dull brown, and the 3rd Earl of Egremont decided to reverse the original effect by painting the background panelling white. The white paint was stripped off about 1870, and the carvings are now difficult to distinguish from their surroundings.

Today, brown predominates in many British country houses, and few houses are browner than Dyrham Park in Gloucestershire, which was completely rebuilt and redecorated by William Blathwayt between 1692 and 1704. His architect, Mr Hauduroy, chose walnut from Virginia for the stairs, balusters, doors and mouldings of the new Great Stairs, and had the adjoining Great Parlour and Family Parlour painted with walnut graining to match in the style of the time. The even grander Best Staircase (illustrated on p.9) was constructed from cedar, also from America, and again much of the room was grained to resemble cedar wood. More shades of brown are supplied by the Dutch Old Master paintings, the embossed leather hangings in the halls, and by the oak, walnut and mahogany furniture.

With centuries of dust, wood smoke, tobacco, yellowing varnish and furniture polish, Blathwayt's browns have turned darker still. (Blathwayt himself had rejected one design for his new staircase balusters on the ground that 'this will harbour dust very much'.) But his Victorian successors seem to have relished gloom. The dark walnut graining in the Balcony Room upstairs, which was once thought to be a classic example of late seventeenth-century taste, turns out to be nineteenth-century.

By the 1930s, such sombre browns had gone completely out of fashion. At another late seventeenth-century house, Belton in Lincolnshire, the dark panelling in the Queen's Bedroom was stripped to the bare wood, revealing all its imperfections. At Dyrham, the then tenant, Lady Islington, painted the Walnut Staircase white, and did the same in the Great Hall, which Blathwayt had grained to resemble light oak. But despite her best efforts, Dyrham remains a brown house.

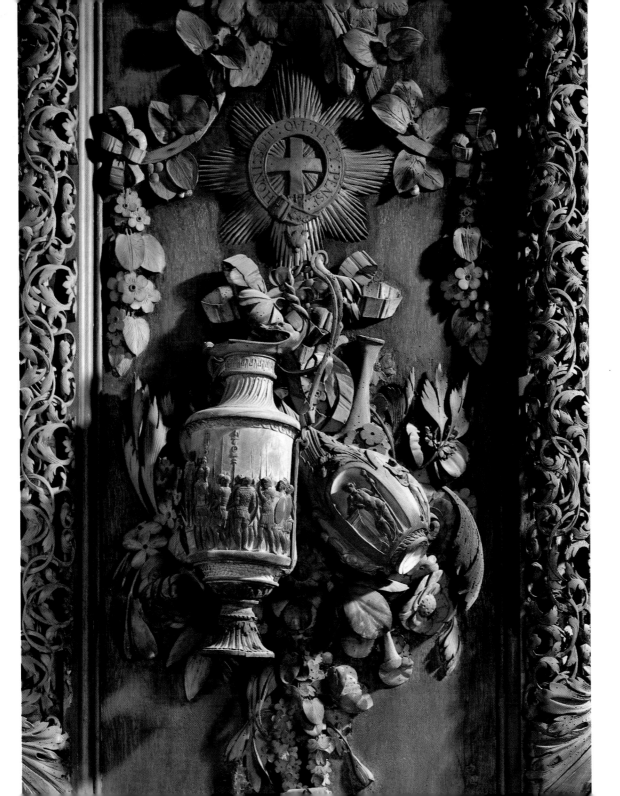

Red

Red is for danger – for fire-engines, stop-lights, falling stock markets and final-demand letters. At Souter Lighthouse in South Tyneside, the secondary light turns from white to red if you sail too close to the rocks. Red hair is supposed to denote fiery temperament, particularly in women. Bess of Hardwick, the builder of Hardwick Hall in Derbyshire, and the Duchess of Lauderdale, who transformed Ham House in Surrey, both had red hair and both were very strong characters. Red is the colour associated with Rebecca, the absent anti-heroine of Daphne du Maurier's novel of that name. The frightening room in which Jane Eyre is locked away at the beginning of Charlotte Brontë's novel has deep red damask bed and window curtains, a red carpet, crimson table cloth and fawn-pink walls.

But red can be welcoming. Even before archaeologists had begun uncovering rooms decorated entirely with red in the classical ruins of Herculaneum, designers had realised that red makes a good background for pictures. When John Parker was creating the Morning Room at Saltram in Devon in the 1740s, he chose a red Genoese silk velvet for the wall-hangings, which still survive. Red picture rooms are also to be seen at Felbrigg Hall in Norfolk, Uppark in Sussex, Attingham Park in Shropshire, Petworth in Sussex, and Cragside in Northumberland, among National Trust houses. This tradition in private houses influenced the decoration of Britain's first public art galleries, many of which have revived their original schemes in recent years, replacing 1960s beiges with more rumbustious and authentic reds.

John Parker was an early patron of Devon's greatest artist, Sir Joshua Reynolds, so it is not surprising to find many of his pictures hanging in the Morning Room at Saltram. Alas, Reynolds used a fugitive red lake pigment, which soon faded, as another client, Sir Walter Blackett of Wallington in Northumberland, complained:

> Painting of old was surely well designed
> To keep the features of the dead in mind,
> But this great rascal has reversed the plan,
> And made his pictures die before the man.

The faces of many a Reynolds sitter, reddened by a life of red meat, red wine and sunshine, are now a deathly white.

[28]

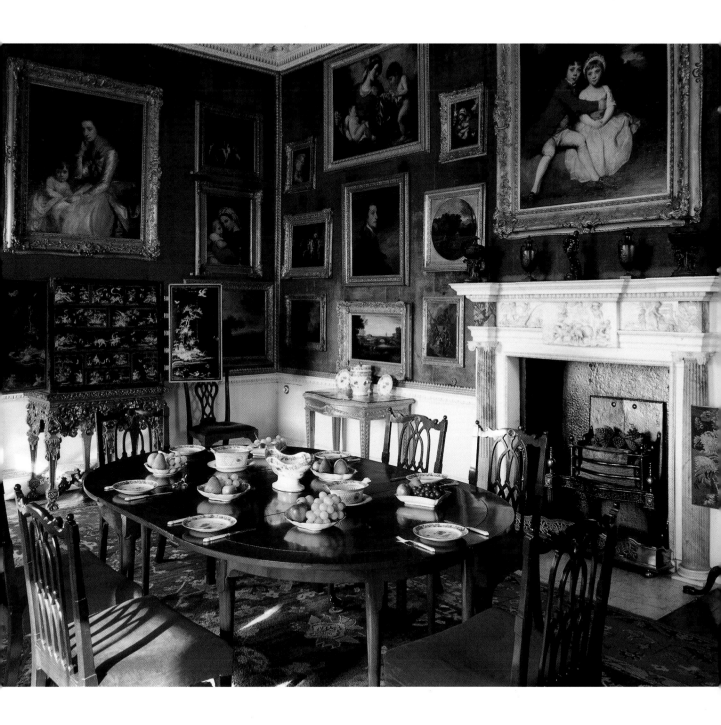

Pink

Confusingly, pink once meant yellow. The word was a noun rather than an adjective, and referred to an organic yellow pigment derived from the broom plant, *Genestella tinctoria*. It was only by the early eighteenth century that it had come to denote a rosy tint. The flower Pink takes its name not from its colour, but from its ragged, or 'pinked', edges. Equally confusingly, 'hunting pink', the dress of the huntsman, is actually scarlet.

Pink is for girls, and has been since at least the time of Madame de Pompadour, the mistress of Louis XV of France. In 1754 she moved the French national china factory from Vincennes to Sèvres, not far from her home at Bellerne southwest of Paris. She was much involved in Sèvres's growing success over the next decade, and gave her name to the pink ground used on many of its wares – *rose Pompadour*. After her death in 1764, at the age of only forty-three, the colour was discontinued as a mark of respect. The English factories at Chelsea and Worcester both tried to copy the colour, but without great success.

In Chinese ceramics, the so-called *famille rose* style of decoration used a range of colours from pink to purple, which became very popular with British country-house collectors in the eighteenth century. The best examples were probably those produced during the reign of the Emperor Yung Cheng (1723–35). The pink glaze was produced by a pigment known as Purple of Cassius, which was first manufactured in Holland by Andreas Cassius of Leyden before 1673. Dutch Jesuit missionaries subsequently took the secret with them to China, from where it was re-exported back to Europe.

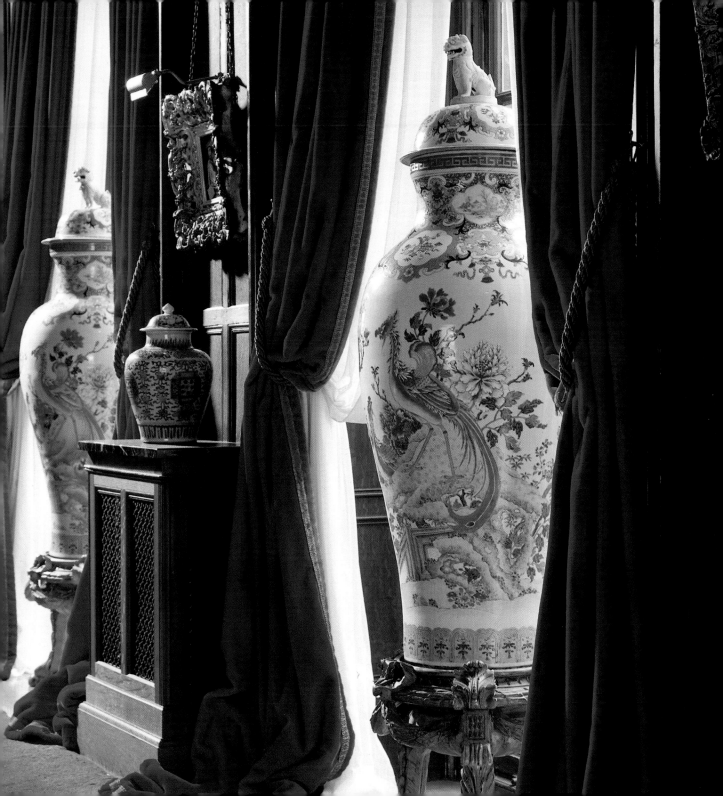

Orange

Oranges was painted in Seville by Antonio Mensaque in 1863 and now hangs in the Library Corridor at Anglesey Abbey in Cambridgeshire. Seville oranges are the main ingredient of marmalade, which first brought a splash of orange to Scottish breakfast tables in the eighteenth century, when the Keiller family started selling Dundee marmalade. It was marmalade money that paid for Alexander Keiller's excavation of the Avebury stone circles in the 1930s.

Orange is a colour rarely found in historic interiors, although the Duchess of Lauderdale – no shrinking violet – seems to have combined it with red at Ham in the late seventeenth century. With the accession of the Protestant William of Orange in 1688, the colour gained strong political overtones in Britain, which are still reflected in the sashes of the Ulster Orangemen. In the eighteenth century it was generally restricted to Neo-classical ceilings, and it was used sparingly there. More frequent are references to shades of cinnamon. So for instance, in 1692, Ridgeway, the house steward at Erddig in Clwyd, reports that a room has been painted 'sumewhat like a sinnimone culor'. The colour orange really became widespread in British homes only after 1935, when Allen Lane chose it for the spines of his Penguin paperback novels. It became briefly fashionable again in the 1970s: the interior designer John Fowler chose orange striped wallpaper when redecorating the Dining Room at Fenton House in London in 1973–4.

Oranges themselves brought the colour into the house. Francis Carew of Beddington in Surrey is said to have been the first person to grow oranges in England, having brought plants from France in 1562. He was also the first person to build an orangery specially for them, comprising 'a tabernacle of boards warmed by means of stoves', according to John Evelyn. By the late seventeenth century, orangeries had become more substantial structures, like the red-brick building at Ham, which was probably erected in 1672–4, but may be even older. Protected from the winter frosts, in summer the orange trees could be wheeled out into the garden in their wooden tubs. Sometimes, they were brought into the house, as in the Stone Gallery at The Vyne in Hampshire, which Mrs Lybbe Powys noted that 'they make a greenhouse of in winter, and they say has a most pleasing effect to walk tho' the oranges, myrtles, &c. ranged on each side'. Orange trees are once again being grown in the mid-eighteenth-century Orangery at Hanbury Hall in Worcestershire. Orange blossom, which is white, appears in many portraits, as it symbolises marriage.

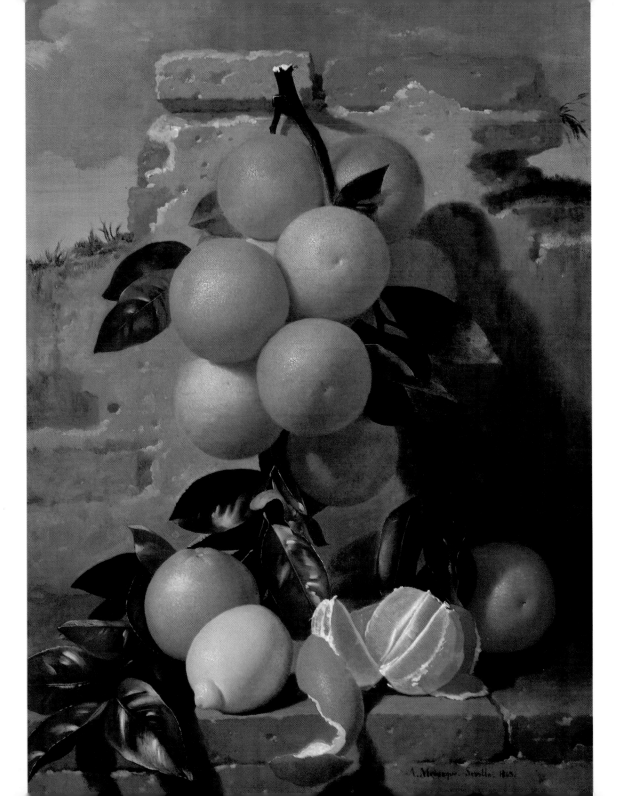

Yellow

Using yellow in quantity requires bravery. In the Drawing Room of Sir John Soane's house in Lincoln's Inn Fields, the effect (recently restored) is scintillating. But when the Duke of Wellington decided on a yellow Picture Gallery for Apsley House in London in 1830, his friend Mrs Arbuthnot was appalled: 'He is going to hang it with yellow damask, which is just the very worst colour he can have for pictures & will kill the effect of the gilding. However, he will have it.' Visitors can judge for themselves whether she was right. In 1969 John Fowler made the bold decision to paint the huge staircase hall at Sudbury in Derbyshire a warm yellow. He had earlier used a paler yellow in the equally large North Hall at Claydon in Buckinghamshire.

Yellow was traditionally the exclusive privilege of the Chinese emperor, and it still has connotations of the exotic. Aubrey Beardsley, the brilliant illustrator of *The Yellow Book*, may have worked in black and white, but he wore lemon yellow gloves and painted his London studio yellow. When Oscar Wilde was arrested in the Cadogan Hotel, he is said to have been reading a yellow-bound French novel – that symbol of everything disreputable to high-minded Victorians.

The last of the great feudal aristocrats, Hugh Lowther, 5th Earl of Lonsdale (1857–1944), was nicknamed 'the Yellow Earl', from his yellow carriages (later motor cars) and the immaculate yellow livery of his grooms. In 1880 he challenged the world heavyweight champion, John L. Sullivan, to a boxing match, and is said to have knocked him out after six rounds; he later sponsored the Lonsdale Belts. By the time he unexpectedly inherited the title in 1882, he had already pawned his inheritance, but this did not stop him living on a lavish scale and running a large string of racehorses. As the *Dictionary of National Biography* concluded, 'With his side-whiskers, his nine-inch cigars and his gardenia buttonhole, he was to the crowds the perfect specimen of the sporting grandee.' His estates included Lonsdale Commons, 17,000 of the most beautiful and remote acres in the Lake District, which have been leased to the National Trust on a peppercorn rent since 1961.

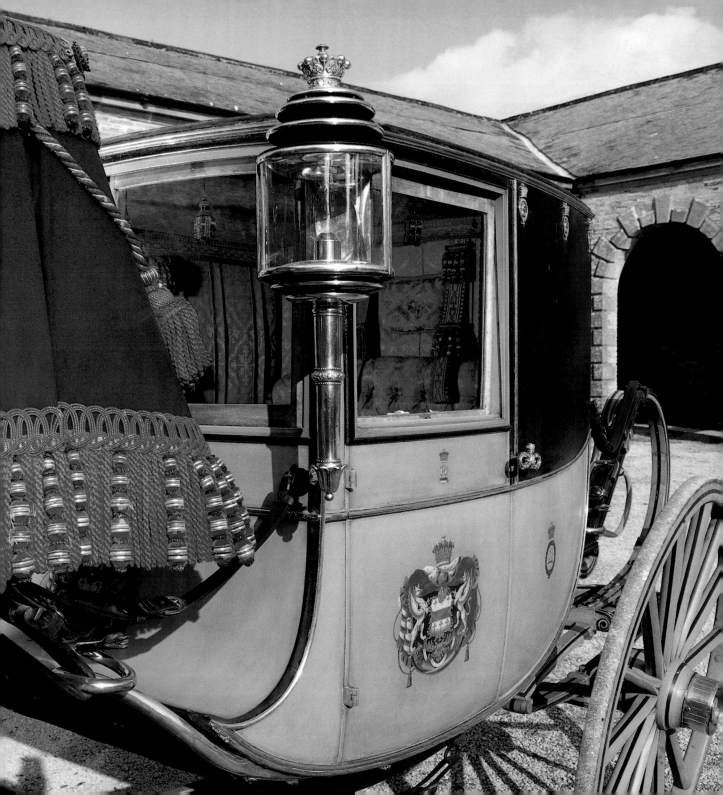

Green

Nina Cust's green library at Chancellor's House, Hyde Park Gate.

When the Grosvenor Gallery first opened its doors in 1877, Edward Burne-Jones was dismayed to discover that his paintings had been hung in the traditional fashion on crimson silk damask. Such a bright colour, he felt, would suck the life out of his low-toned, dreamlike canvases, and he persuaded the organiser to redecorate in a more restful olive green. Theatre green-rooms are green precisely because the colour is easy on the eye after the harshness of stage lighting.

Green had become a popular colour for picture rooms since at least 1638 when the little Green Parlour at Ham was first recorded as containing a precious collection of miniature 'cabinet' pictures hung on green damask. Robert Adam seems to have preferred it, perhaps above all other colours: no fewer than forty of his ceiling designs in the Soane Museum include green, and he used it extensively throughout Osterley Park in Middlesex. Associated with spring and fertility, it was the ideal colour for the elaborate state bed designed for Robert and Sarah Child in 1776, although the couple were to have no more children. He also painted the walls of the Osterley staircase an olive green, and hung the Long Gallery with pea green wallpaper.

Green verditer Chinese wallpaper was popular throughout the eighteenth century, particularly for bedrooms. At Nostell Priory in Yorkshire it was strikingly combined with Thomas Chippendale's brilliant green lacquer chinoiserie furniture. Fragile green-painted original chairs stand in the central octagon of the unique, sixteen-sided house at A la Ronde in Devon created in the 1790s by the Parminter cousins. The Parminters used green – marbled, sponged and plain – throughout the interior with the same boldness displayed in their famous shell decorations. Green was the most popular colour for London front doors in the late eighteenth and early nineteenth centuries.

In the 1820s wallpaper-makers first began using a new

emerald green pigment to colour the papers. Unfortunately, this contained arsenic, and so was highly toxic. Several people were poisoned by the green wallpaper, and it even featured in a notorious murder case.

Burne-Jones's passion for green w

ared by many of his patrons, who belonged to an intellectual literary circle known as the Souls. One such as Nina Welby-Gregory, the long-suffering wife of the insatiable philanderer Harry Cust. She painted the library of her London house entirely in green, to give it a flavour of the country and of her wild garden, which it overlooked. The natural overtones of green appealed strongly to the pioneers of the Arts and Crafts movement, so it is not surprising that one of its key figures, the architect Philip Webb, chose a solemn green for the walls of the Dining Room at Standen in Sussex. Virginia Woolf, sister of a painter and an intensely visual writer, loved green as much as Burne-Jones, painting her main Sitting Room at Monk's House in Sussex in a vivid shade.

Blue

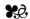

The fashion in Europe for blue-and-white Chinese ceramics began in the early seventeenth century, when huge quantities of 'kraak' porcelain were imported by Portuguese and Dutch traders. Chinese makers began producing blue-and-white specifically for this market, adapting traditional motifs to European shapes. Dutch Delftware also catered for lovers of blue-and-white. By the end of the century, Queen Mary and other devotees were displaying their collections on stepped corner chimneypieces like those at Ham and Beningbrough Hall in Yorkshire. At the German palace of Oranienburg blue-and-white pots on wall brackets covered entire rooms.

The taste for collecting blue-and-white revived in Britain in the 1860s, thanks to the painter D.G. Rossetti. As he admitted to a friend: 'I pant and gasp for more.' For Pre-Raphaelite artists like Rossetti, who had started out trying to record the precise colours of nature, blue – the colour of the sky – held a particular fascination. When working on the Oxford Union murals in 1857, Rossetti had insisted on using real ultramarine, an immensely expensive blue pigment made from *lapis lazuli*, the best samples of which come from a remote mine in Afghanistan. Unfortunately, he then managed to tip over an entire pot of the pigment. William Morris's hands were permanently stained blue from his efforts to recreate the recipe for woad, a natural indigo dye extracted from the green leaves of the herb *Isatis tinctoria*. Morris not only used this blue to dye the tapestries and curtains produced by his firm, but also to dye his own shirts. Since then, every serious designer has worn a blue shirt.

In collecting blue-and-white, Rossetti found himself in ferocious rivalry with another painter, James Whistler, and, as Rossetti's brother explained, 'it seems that in collecting, as in love and war, everything is fair'. Rossetti would invite rival collectors to dine off his best blue-and-white, which was hidden under a table-cloth that was whisked off at the last moment for greatest effect. Rossetti was especially keen on covered ginger jars decorated with branches of blossoming prunus – he called them 'hawthorn' pots – which he incorporated into the background of his painting, *The Blue Bower* (in the Barber Institute of Fine Arts, Birmingham). He called it simply 'an oil-picture all blue', and it derives its power, like the pots themselves, from using the most intense cobalt blue. Whistler also incorporated blue-and-white china in many of his paintings, and indeed designed an entire room with blue walls specifically to display it. The Peacock Room (now in the Freer Gallery in Washington) was unique, but something of the effect can still be seen in the Great Parlour at Wightwick Manor in the West Midlands.

Purple

Purple has symbolised power since at least the time of the Roman Republic, when senators wore tunics bearing a broad stripe of Tyrian purple. The dye was derived from the shellfish *Murex brandaris* and was immensely laborious and expensive to produce: 12,000 murex shells were needed to make just 1.4 grams of the dye. Purple remained the distinguishing colour for the Roman and the Byzantine imperial families. Indeed, the latter acquired their own adjective, '*porphyrogenitus*', meaning 'born in the purple' – as they literally were: a special room was set aside in the Imperial Palace in Constantinople for the birth of the Byzantine Emperor's children, entirely lined with the purple stone porphyry. The stone also gave its name to a disease with royal connections – porphyria. It is this which is now thought to have been responsible for the 'madness' of George III, one symptom of which was to turn his urine purple. The colour purple is still associated with British royalty: the coronation crown is lined with dark purple velvet.

Purple denotes spiritual as well as temporal authority. Each of the seven sacraments in Rogier van der Weyden's painting of that theme in Antwerp is given its own appropriately coloured angel: purple represents ordination into the priesthood. Anglican bishops still wear purple amethyst rings, and, during Lent, purple vestments, as the colour also symbolises penance.

Power corrupts, and so it is not surprising that purple can also represent corruption. In his poem *Lamia* (1820) Keats described the home of the doomed Corinthian lover Lycius as 'that purple-lined palace of sweet sin'. In 1907 Lord Curzon's mistress Elinor Glyn scandalised polite society with her erotic novel, *Three Weeks*. In it, the young hero is led astray by a mature seductress, who dresses in 'some strange clinging garment of heavy purple crêpe' and inhabits a love-nest 'piled with pillows, all shades of rich purple velvet and silk, embroidered with silver and gold'.

Purple appears less often in more ordinary interiors. Samuel Pepys experimented with painting his small cabinet room purple, but seems to have thought better of it. In 1683, the walls of the Duchess of Lauderdale's Closet at Ham House, Surrey, were hung with 'Dark Mohayre bordered with flowered silke with purple & gold fringe' – an effect that was reproduced at Ham by the Victoria & Albert Museum. In the 1690s the fluted pilasters in the Balcony Room at Dyrham in Gloucestershire was painted to resemble porphyry. Robert Adam occasionally used purple on his ceilings – a light shade in the Drawing Room at Osterley, a darker shade in the Dining Room at Kedleston, which has recently been restored.

Translucent Colour

Were not the bars of darkness in the room, and the yellow pools which chequered the floor, made by the sun falling through the stained glass on a vast coat of arms in the window? Orlando stood now in the midst of the yellow body of an heraldic leopard. When he put his hand on the window-sill to push the window open, it was instantly coloured red, blue, and yellow like a butterfly's wing.

Virginia Woolf, *Orlando* (1928)

December, from the 'Months of the Year' stained glass designed by Thomas Willement for the Grand Hall at Penrhyn Castle in Gwynedd.

Alec Clifton-Taylor called the wholesale destruction of medieval stained glass 'the greatest calamity that has ever befallen English art'. Not only the great cathedrals, but almost every parish church, large and small, would have contained at least some medieval glass. Thanks to the Dissolution of the Monasteries, the Civil War and the eighteenth century, it has now almost entirely gone. It is hard today to imagine what it must have been like to be bathed in such gloriously coloured light, if you were an ordinary worshipper, used to wearing dull-coloured clothes and living with little artificial light. Ruskin put it well, when he likened the intense colours of medieval glass to 'flaming jewellery'.

Much early stained glass to be found in country houses is heraldic, like that evoked by Virginia Woolf in *Orlando*, which was inspired by memories of Knole in Kent. It was as heraldic artist to George IV that Thomas Willement, the great Regency reviver of stained glass, made his name. In the Great Hall at Charlecote, Warwickshire, Willement repaired the Tudor heraldic glass recording the descent of the Lucy family up to 1558, and installed new glass in a very similar style to commemorate the later generations. For the Grand Hall of Penrhyn Castle in Gwynedd, he was able to design glass on a cathedral scale. Indeed, his signs of the zodiac and months of the year in vibrant reds and blues were inspired by the thirteenth-century glass in Canterbury Cathedral. On a smaller scale, the *Four Seasons* glass that Morris & Co. supplied for the Dining Room inglenook at Cragside in Northumberland brings colour into a dark greeny-brown interior.

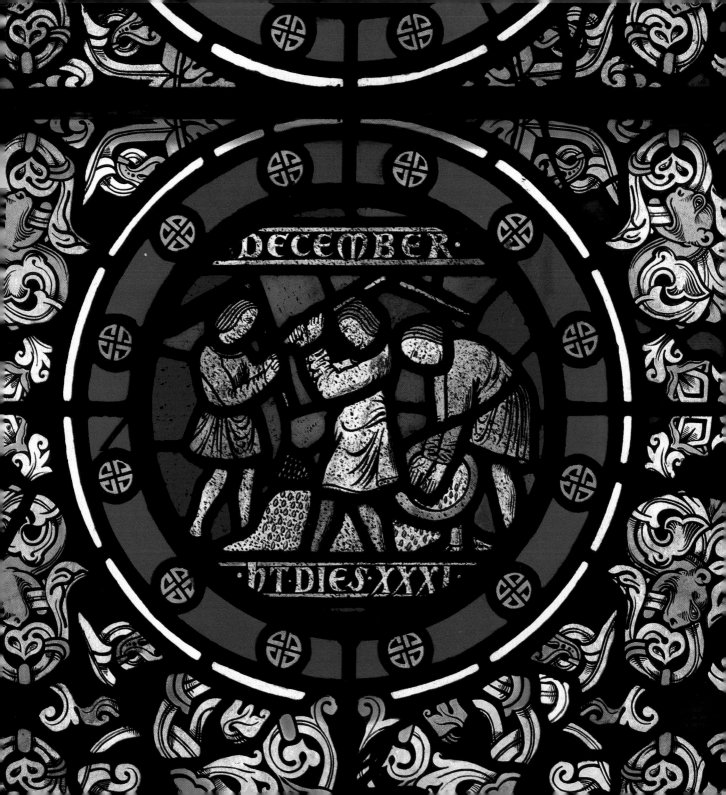

Colour subdued by Time

This eighteenth-century lacquer cabinet at Erddig still retains its brilliant red interior, which has been protected from the light. The lower drawers have faded to a gentle brown.

Without light, we cannot enjoy colours. But too much sunlight will fade those colours, particularly the invisible, ultraviolet light that lies beyond the purple end of the spectrum and can cause irreversible photochemical damage. Most susceptible are those organic materials which abound in most old houses – wood, cloth, paper, leather. Exposed to the sun for too long, furniture will bleach and crack, medieval tapestries will turn to a uniform blue, watercolours will fade, and leather bindings will crumble to dust.

We may respond instinctively to the mellow colours of an old house in the same way as Dorothea Brooke in George Eliot's *Middlemarch* (1871–2). When she visits Mr Casaubon's manor house at Lowick, she finds 'all that she could wish: the dark bookshelves in the long library, the carpets and curtains with colours subdued by time'. But in the past, most country-house owners went to a great deal of trouble to prevent their possessions mellowing. When they were away, which could be for long periods if they had a house in London, the shutters would be closed, the covers would shroud the furniture, and the rooms would hibernate in the half-light. Susanna Whatman, who lived at Turkey Court in Kent during the 1770s, was very conscious of the dangers of unrestricted sunlight, and in her 'Housekeeping Book' she carefully recorded the precautions she had taken: 'The sun comes into the Library very early. The window on that side of the bow must have the blind let down…. Drawing room. The blinds always closed in the morning and window up…. Eating Parlour. The sun never comes in…. Mrs Whatman's Dressing room. The sun must always be kept out, or it will spoil the carpet, chairs and mahogany cabinet.'

The National Trust keeps up this tradition of good housekeeping. You may find blinds drawn on sunny days, but this is only to ensure that your successors in years to come will not have to walk round rooms drained of colour.

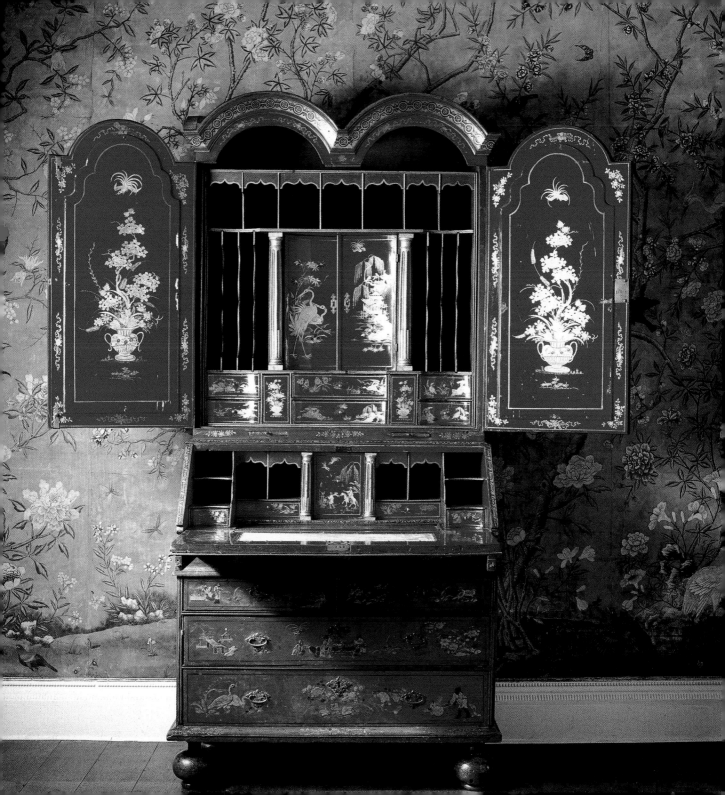

Colour and the National Trust

Uppark in West Sussex was the classic example of a country house that had mellowed gradually with time. This was largely thanks to its quiet history since the death of Sir Harry Fetherstonhaugh in 1846, and to the care that Lady Meade-Fetherstonhaugh devoted to the house in the 1930s. Tired paintwork had been cleaned rather than painted over, and the colours of the crimson curtains had been revived by washing them in a traditional detergent made from the herb *Saponaria*.

When Uppark was rebuilt following the devastating fire in 1989, it would have been simplest to repaint it completely. But in keeping with Uppark's long tradition of careful conservation and the National Trust's philosophy of restoring the house to its previous state 'insofar as that is practicable', it was decided to preserve any surviving paint colours and to inpaint the losses. And because the heat of the fire had gone straight upwards, much of the paint and gilding on the walls of the Saloon, the grandest room in the house, had survived. Technical analysis by Catherine Hassall and Patrick Baty established that the Saloon had only ever been painted three times in over two hundred years. When first created *c.*1770, it had been dark green with stoney white for the raised decoration. It was then repainted a paler green with white highlights, a scheme that was found still preserved behind the bookcases. Finally, around 1815, Humphry Repton had it painted in a lead white, which underwent 'Scowering & Cleaning' in 1831, but had never been repainted since. With time, it gently faded to the present grey-green tone, which the National Trust carefully matched in a milk-based casein paint so that this rare ensemble of furniture, pictures, carpets and upholstery could sit together in harmony once again. Elsewhere in the house, it proved possible to use traditional lead-based paint, mixed to the old formula by Hirst Conservation Ltd, but artificially aged so that it will mature at the same rate as the surviving old paintwork it complements.

Matching the faded colours of Uppark has been one of the National Trust's most complex challenges recently, but it faces similar issues in many other houses. For several years, it has worked with the paint firm, Farrow & Ball, to reproduce traditional paint recipes specifically for use in historic houses. Farrow & Ball now produces a paint range inspired by the colours found in Trust houses – both flat, faded off-whites for old plasterwork ceilings, and such startlingly bright shades as Berrington blue, based on the blue scagliola columns in the Boudoir at Berrington Hall in Herefordshire.

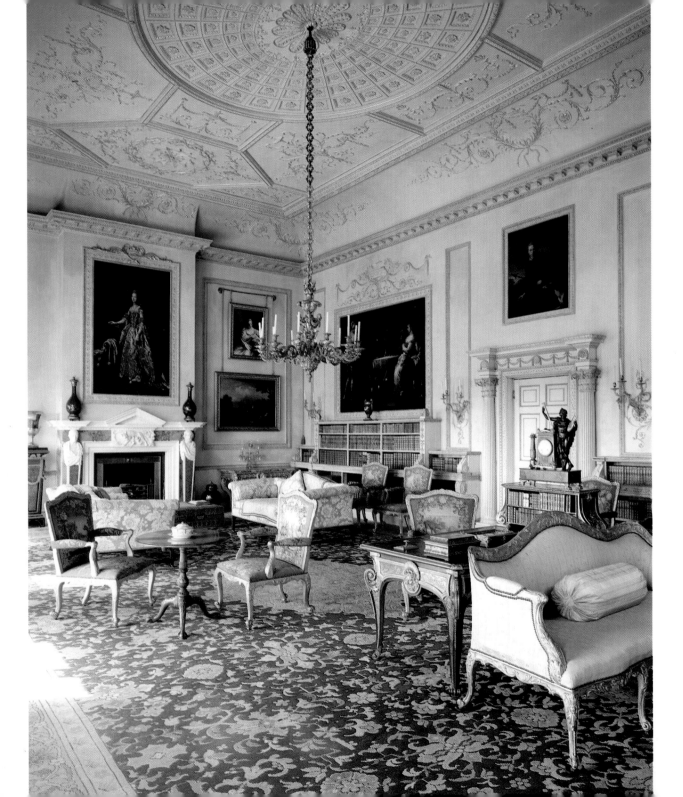

Further Reading

ASHELFORD, Jane, *The Art of Dress*, The National Trust, London, 1996.

AYRES, James, *Building the Georgian City*, Yale University Press, New Haven, 1999.

BATTERSBY, Martin, *The Decorative Thirties*, Studio Vista, London, 1971.

BRISTOW, Ian C., *Interior House-painting Colours and Technology 1615–1840*, Yale University Press, New Haven, 1996.

— *Architectural Colour in British Interiors 1615–1840*, Yale University Press, New Haven, 1996.

CAMPBELL, Marian, *Decorative Ironwork*, Victoria & Albert Museum, London, 1997.

CLIFTON-TAYLOR, Alec, *The Pattern of English Building*, Faber, London, 1972 and 1987.

CORNFORTH, JOHN, 'Picked out with silver', *Country Life*, 6 August 1992, pp.54–5.

CRUIKSHANK, Dan, and Neil Burton, *Life in the Georgian City*, Viking, London, 1990.

ESTERLEY, David, *Grinling Gibbons and the Art of Carving*, Victoria & Albert Museum, London, 1998.

GAGE, John, *Colour and Culture*, Thames & Hudson, London, 1993.

— *Colour and Meaning*, Thames & Hudson, London, 1999.

HARDYMENT, Christina (ed.), *The Housekeeping Book of Susanna Whatman*, 1776–1800, The National Trust, London, 2000.

HARLEY, R.D., *Artists' Pigments, c.1600–1835*, Butterworth Scientific, London, 1970; second edition, 1982.

IONIDES, Basil, *Colour and Interior Decoration*, Country Life, London, 1926.

MERRILL, Linda, *The Peacock Room: A Cultural Biography*, Yale University Press, New Haven, 1998.

MORDAUNT CROOK, J., *The Rise of the Nouveaux Riches*, John Murray, London, 1999.

Paint & Painting, Tate Gallery, London, 1982.

PATMORE, Derek, *Colour Schemes for the Modern Home*, Studio, London, 1933.

SIMON, Jacob, *The Art of the Picture Frame*, National Portrait Gallery, London, 1996.

SNODIN, Michael, and Maurice Howard, *Ornament*, Victoria & Albert Museum, London, 1996.

THEROUX, Alexander, *The Primary Colours*, Picador, London, 1995.

WATERFIELD, Giles, *Palaces of Art: Art Galleries in Britain 1790–1990*, Dulwich Picture Gallery, London, 1992.